SID ROTH'S THE 31 HEALING
MIRACLES OF JESUS

DESTINY IMAGE® PUBLISHERS, INC.
P.O. Box 310, Shippensburg, PA 17257-0310
"Promoting Inspired Lives."

It's Supernatural and Messianic Vision Inc.
4301 Westinghouse Blvd.
Charlotte, NC 28273

This book and all other Destiny Image and Destiny Image Fiction books are available at Christian bookstores and distributors worldwide.

Cover Design by Eileen Rockwell
Interior Design by Terry Clifton

For more information on foreign distributors, call 717-532-3040.

Reach us on the Internet: www.destinyimage.com.

ISBN 13 TP: 978-0-7684-1430-1

For Worldwide Distribution, Printed in the U.S.A.

1 2 3 4 5 6 7 8 / 21 20 19 18 17

MIRACLES

Foreword

God creates in His coloring book called the world, and we get to watch His beautiful designs in nature, sunsets, and in the faces of those we love. In my book, *Born to Create*, I share about this concept found in the beginning of the book of Genesis. In chapter one, it says we are made in God's image (Genesis 1:27); so therefore, we *are* creative because we reflect the nature of God. This desire to create, though, can be taken from us because of the busyness of life. Simple coloring exercises can return the joy of creating—just for the sheer fun and way to let go as we create.

And there is more…

I believe that coloring is a form of healing in which we begin to pick up the colors we are drawn to and create beauty from simple forms of black and white. Not only can this draw us close to our creative nature, but we can partner this with healings from the Bible, where these stories can come to life as we creatively express them through our colors.

Not only does God desire us to create, but studies from the Mayo Clinic in Rochester, Minnesota share about the benefits of coloring: "It's almost like a volume knob to turn down the sympathetic nervous system, the stress response."[1] I want to encourage you to use this coloring book as a way to tap into God's healing path for you.

As you meditate on the stories found in this coloring book, take some time and ask God to reveal His nature of healing *for you* as you color. See His desires for rest and peace for your soul and for healing to your body. Jesus is *still* creating life through His Spirit, so dip into the colors of His nature and see God's presence flood you as you create in this coloring book!

Let's open up the pages and CREATE!

THERESA DEDMON
Author: *Born to Create*

1. Craig Sawchuk, qtd. in Nora Krug, "Why Adult Coloring Books Are the Latest Trend," *The Washington Post Health and Science,* May 2, 2016, https://www.washingtonpost.com/national/health-science/adult-coloring-books-are-not-just-a-fad-for-some-they-are-a-lifesaver/2016/05/02/47449320-f8c2-11e5-a3ce-f06b5ba21f33_story.html.

Introduction

Partner with the Holy Spirit and Release His Healing Power

Experience the healing miracles of Jesus like never before!

Often, when we think of Biblical meditation or reflection, immediately, our minds go to Scripture memorization. This is one expression of Biblical meditation, but not the only one.

Coloring is a powerful way for you to focus on the healing power of Jesus. Not only are you reading through the different Gospel accounts, describing various miracles of Jesus, but you are personally interacting with them through coloring. It's like you are entering into the story of that specific miracle in a way that is absolutely unique.

Partner with the Holy Spirit

As you begin this journey, you are actually partnering with the Holy Spirit. You are positioning yourself to experience His supernatural healing power by focusing on the different miracles that Jesus performed.

While you interact with every detail of the picture, ask the Holy Spirit to build your faith. It's more than a coloring book—it's an invitation to encounter and yes, even repeat the same miracles that Jesus performed. Remember, He never meant those miracles to be restricted to only Him.

> *"Most assuredly, I say to you, he who believes in Me, the works that I do he will do also; and greater works than these he will do, because I go to My Father. And whatever you ask in My name, that I will do, that the Father may be glorified in the Son."* (John 14:12-13)

How is it that you can do the *same works* that Jesus did—and even *greater works?* Simple. Because Jesus went to the Father. Sounds strange, since we often daydream about how great life would be if Jesus was here *with us right now.* The truth is, He is. He's with us in a way He could have never been with us while He was physically walking the Earth. Jesus said that it was to our

benefit and advantage that He went away to the Father so that, in exchange, He could send us the Holy Spirit (see Jn. 16:7).

In Jesus, the power of God was locked up in the body of one Man. Through the Holy Spirit, millions across the Earth can experience this supernatural power at *any time*. God is now accessible to whoever would call upon His name.

Experience the Creative Healing Power of God…Through Coloring!

It's the Holy Spirit Who makes it possible for you and I to receive healing miracles by going through a coloring book.

Often times, our minds resist the supernatural and miraculous because they are not logical. Coloring has a way of bypassing the skepticism of our minds and brings us to focus on the *picture* of Jesus, the Healer.

Here is how I would like you to interact with this one-of-a-kind coloring book:

1. Ask the Holy Spirit to lead you through every image and picture you color. Pray that God would open your eyes to see new revelation and detail into healing stories that you think you're familiar with.

2. Listen to worship music while coloring. Consider it an act of worship and encounter. "Soaking music" is different than typical praise and worship, in that it positions you to simply enjoy the Presence of God and receive from the Father.

3. Meditate on the Scriptures that are included. Remember, Biblical meditation is about filling your mind with the Word.

More than anything, enjoy the creative process with God! Ask the Holy Spirit to come and saturate you in the process.

Release Extraordinary Miracles Through Your Artwork!

In Acts 19:11-12, we catch a glimpse of how God performed some *unusual* and *extraordinary* miracles through the Apostle Paul. One might even categorize these as examples of the "greater works" that Jesus promised.

> *Now God worked unusual miracles by the hands of Paul, so that even hand-kerchiefs or aprons were brought from his body to the sick, and the diseases left them and the evil spirits went out of them.*

How does this passage relate to your coloring experience? We believe that, even though these coloring activities will bring you into new realms of God's presence and release His healing power over you, personally, there is another dimension waiting for you to tap into.

Allow each *healing* image to be a worship encounter between you and the Holy Spirit. Invite His presence to come saturate you during your coloring session. God wants to touch, heal and deliver you—and He wants to touch, heal and deliver *through* you. Could it be that your picture becomes a point of contact for someone else? Is it possible that, like with the Apostle Paul and the pieces of clothing from his body, your pictures can become so saturated in God's presence that you can also release healing and deliverance to your friends and family? Yes.

You can also walk in unusual, extraordinary miracles! One way you can start is by sharing your artwork with those who need to experience God's healing power in their own lives. The pages are perforated, so you can either frame your work or—if you feel so directed by the Spirit—share your artwork with those who need a miraculous touch from the Lord. Remember the pieces of cloth that were taken from the Apostle Paul? They were not anointed because they were prayed over; they were anointed because Paul lived saturated in the presence of the Holy Spirit. Get ready for the residue of your encounters with the Holy Spirit, while coloring, to saturate the very pages of your artwork.

This is also a great opportunity to begin discussions with others about God's healing power and desire to heal. People who do not even know the Lord yet can experience His miraculous power through your artwork because the Holy Spirit's presence is all over it!

PREPARE TO ENCOUNTER THE SUPERNATURAL!

We believe this resource will position you to experience and release the supernatural power of God. By coloring through these incredible miracle stories from the Gospel accounts, you will:

- *Remember the testimonies* of God's supernatural power, as revealed in the healing miracles of Jesus.

- *Build your faith* to believe for Jesus to work the same miracles today that He did in the Bible accounts you are coloring.

- *Encounter the saturating Presence of God* by meditating on the miracles and healings of Jesus.

- *Release God's healing power* by sharing your Holy Spirit-saturated artwork with others who are in need of a miracle.

The coloring book phenomena has become popular because it is said to be an excellent stress reliever, especially before bedtime.

As you go through this unique collection of Gospel stories, Scripture verses and dynamic images, your stress will go and replacing it will be the healing presence of God. Get ready for a fresh encounter with God the Healer and Miracle-worker as you color your way through *Sid Roth's The 31 Healing Miracles of Jesus.*

JESUS CLEANSES A LEPER

When He had come down from the mountain, great multitudes followed Him. And behold, a leper came and worshiped Him, saying, "Lord, if You are willing, You can make me clean."

Then Jesus put out His hand and touched him, saying, "I am willing; be cleansed." Immediately his leprosy was cleansed.

And Jesus said to him, "See that you tell no one; but go your way, show yourself to the priest, and offer the gift that Moses commanded, as a testimony to them."

—MATTHEW 8:1-4

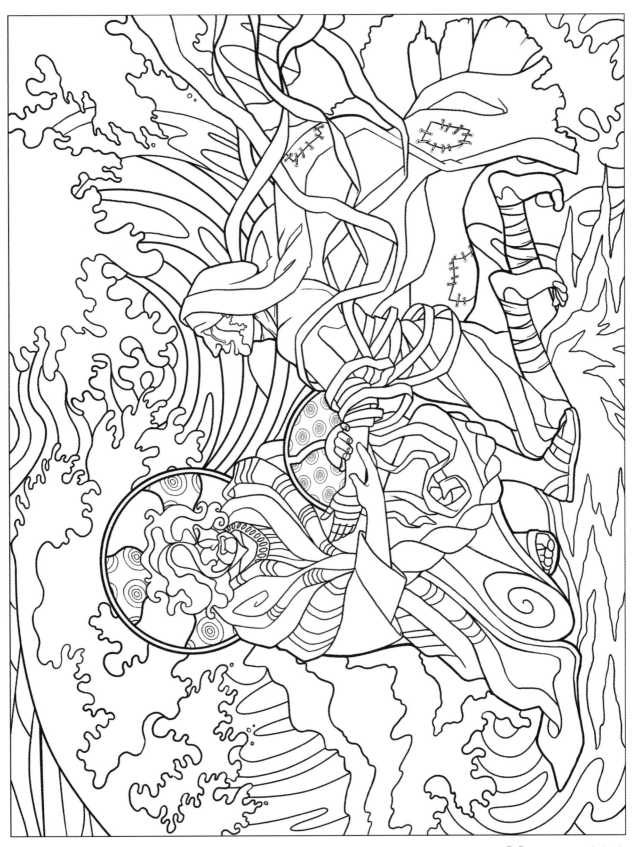

—Matthew 8:1-4

TWO DEMON-POSSESSED MEN HEALED

When He had come to the other side, to the country of the Gergesenes, there met Him two demon-possessed men, coming out of the tombs, exceedingly fierce, so that no one could pass that way. And suddenly they cried out, saying, "What have we to do with You, Jesus, You Son of God? Have You come here to torment us before the time?"

Now a good way off from them there was a herd of many swine feeding. So the demons begged Him, saying, "If You cast us out, permit us to go away into the herd of swine."

And He said to them, "Go." So when they had come out, they went into the herd of swine. And suddenly the whole herd of swine ran violently down the steep place into the sea, and perished in the water.

—MATTHEW 8:28-32

יהוה

—Matthew 8:28-32

TWO BLIND MEN HEALED

When Jesus departed from there, two blind men followed Him, crying out and saying, "Son of David, have mercy on us!"

And when He had come into the house, the blind men came to Him. And Jesus said to them, "Do you believe that I am able to do this?"

They said to Him, "Yes, Lord."

Then He touched their eyes, saying, "According to your faith let it be to you." And their eyes were opened. And Jesus sternly warned them, saying, "See that no one knows it." But when they had departed, they spread the news about Him in all that country.

—MATTHEW 9:27-31

—Matthew 9:27-31

A DEMON-POSSESSED MAN IS MADE TO SEE AND SPEAK

Then one was brought to Him who was demon-possessed, blind and mute; and He healed him, so that the blind and mute man both spoke and saw.

—MATTHEW 12:22

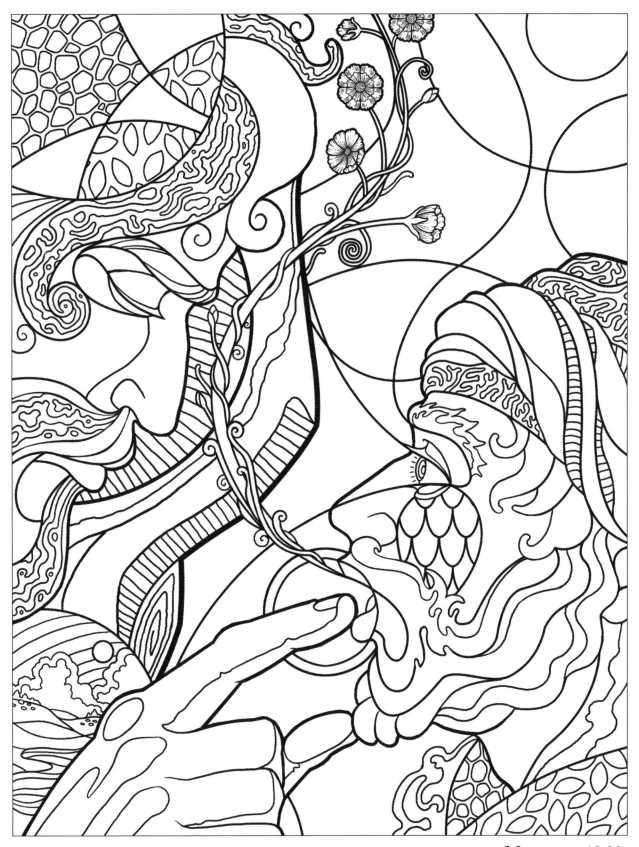

—Matthew 12:22

Jesus Heals Through the Laying-on of Hands in Nazareth

But Jesus said to them, "A prophet is not without honor except in his own country, among his own relatives, and in his own house." Now He could do no mighty work there, except that He laid His hands on a few sick people and healed them. And He marveled because of their unbelief. Then He went about the villages in a circuit, teaching.

—Mark 6:4-6

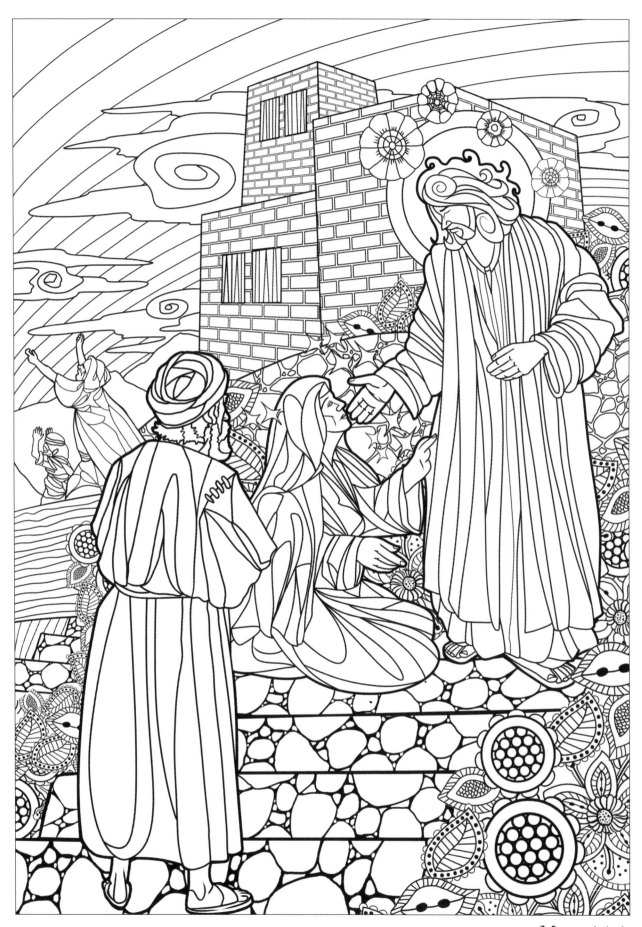

—Mark 6:4-6

JESUS HEALS A GENTILE WOMAN'S DAUGHTER

Then Jesus went out from there and departed to the region of Tyre and Sidon. And behold, a woman of Canaan came from that region and cried out to Him, saying, "Have mercy on me, O Lord, Son of David! My daughter is severely demon-possessed."

But He answered her not a word.

And His disciples came and urged Him, saying, "Send her away, for she cries out after us."

But He answered and said, "I was not sent except to the lost sheep of the house of Israel."

Then she came and worshiped Him, saying, "Lord, help me!"

But He answered and said, "It is not good to take the children's bread and throw it to the little dogs."

And she said, "Yes, Lord, yet even the little dogs eat the crumbs which fall from their masters' table."

Then Jesus answered and said to her, "O woman, great is your faith! Let it be to you as you desire." And her daughter was healed from that very hour.

—MATTHEW 15:21-28

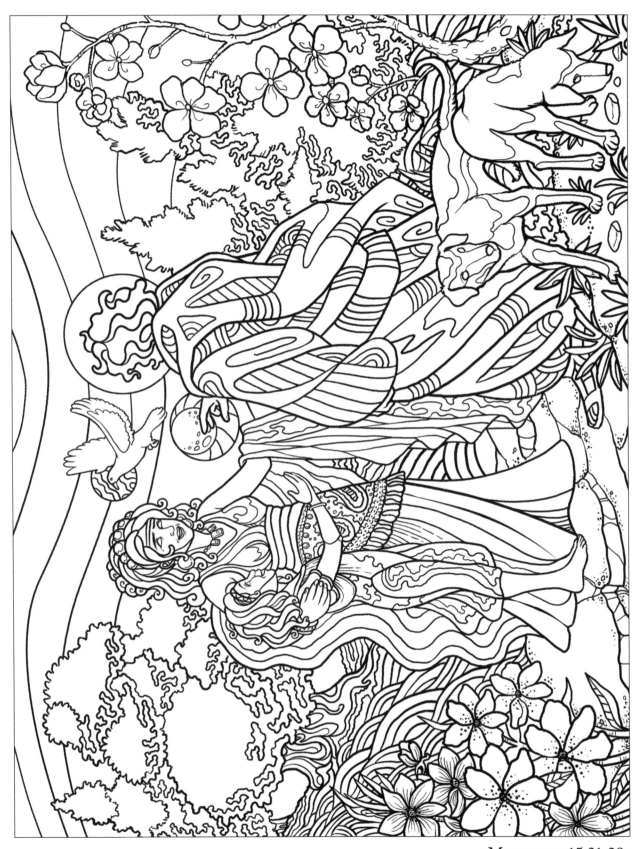

—Matthew 15:21-28

Jesus Heals Great Multitudes

Jesus departed from there, skirted the Sea of Galilee, and went up on the mountain and sat down there. Then great multitudes came to Him, having with them the lame, blind, mute, maimed, and many others; and they laid them down at Jesus' feet, and He healed them. So the multitude marveled when they saw the mute speaking, the maimed made whole, the lame walking, and the blind seeing; and they glorified the God of Israel.

—Matthew 15:29-31

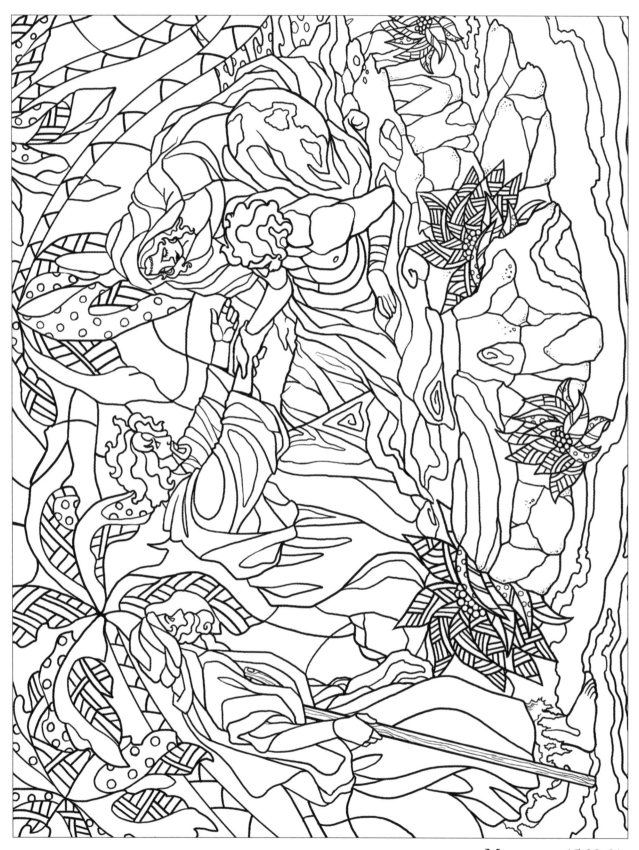

—Matthew 15:29-31

A Boy Is Healed of Epilepsy

And when they had come to the multitude, a man came to Him, kneeling down to Him and saying, "Lord, have mercy on my son, for he is an epileptic and suffers severely; for he often falls into the fire and often into the water. So I brought him to Your disciples, but they could not cure him."

Then Jesus answered and said, "O faithless and perverse generation, how long shall I be with you? How long shall I bear with you? Bring him here to Me." And Jesus rebuked the demon, and it came out of him; and the child was cured from that very hour.

Then the disciples came to Jesus privately and said, "Why could we not cast it out?"

So Jesus said to them, "Because of your unbelief; for assuredly, I say to you, if you have faith as a mustard seed, you will say to this mountain, 'Move from here to there,' and it will move; and nothing will be impossible for you. However, this kind does not go out except by prayer and fasting."

—Matthew 17:14-21

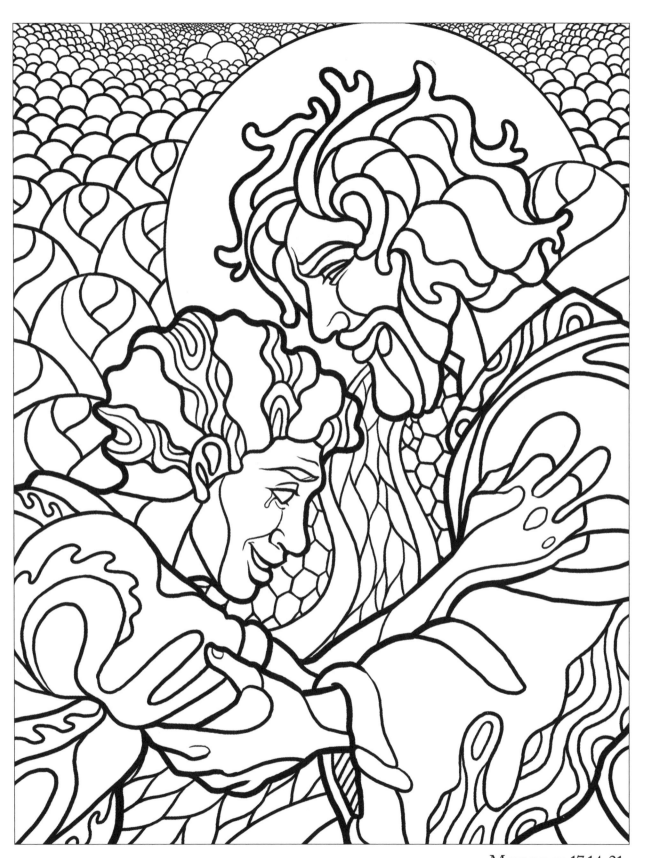

—Matthew 17:14-21

Two Blind Men Receive Their Sight

Now as they went out of Jericho, a great multitude followed Him. And behold, two blind men sitting by the road, when they heard that Jesus was passing by, cried out, saying, "Have mercy on us, O Lord, Son of David!"

Then the multitude warned them that they should be quiet; but they cried out all the more, saying, "Have mercy on us, O Lord, Son of David!"

So Jesus stood still and called them, and said, "What do you want Me to do for you?"

They said to Him, "Lord, that our eyes may be opened." So Jesus had compassion and touched their eyes. And immediately their eyes received sight, and they followed Him.

—Matthew 20:29-34

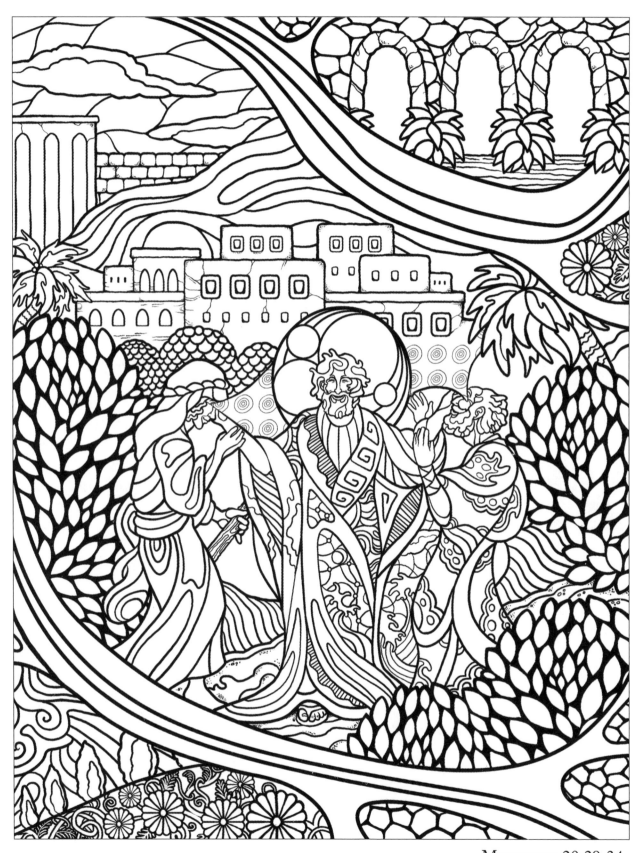

—Matthew 20:29-34

SIMON PETER'S MOTHER-IN-LAW HEALED

Now as soon as they had come out of the synagogue, they entered the house of Simon and Andrew, with James and John. But Simon's wife's mother lay sick with a fever, and they told Him about her at once. So He came and took her by the hand and lifted her up, and immediately the fever left her. And she served them.

—MARK 1:29-31

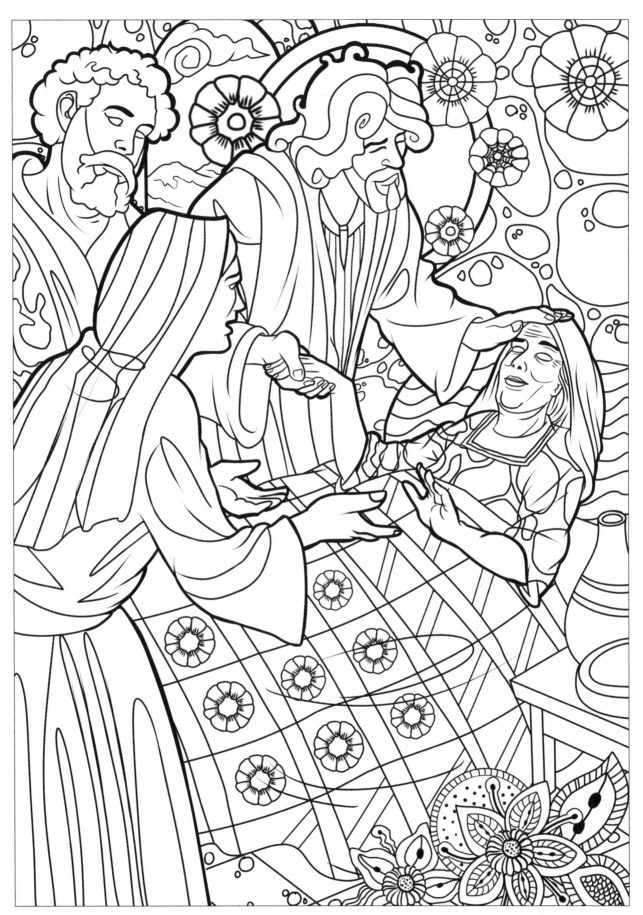

—Mark 1:29-31

Jesus Heals a Withered Hand

And He entered the synagogue again, and a man was there who had a withered hand. So they watched Him closely, whether He would heal him on the Sabbath, so that they might accuse Him. And He said to the man who had the withered hand, "Step forward." Then He said to them, "Is it lawful on the Sabbath to do good or to do evil, to save life or to kill?" But they kept silent. And when He had looked around at them with anger, being grieved by the hardness of their hearts, He said to the man, "Stretch out your hand." And he stretched it out, and his hand was restored as whole as the other. Then the Pharisees went out and immediately plotted with the Herodians against Him, how they might destroy Him.

—Mark 3:1-6

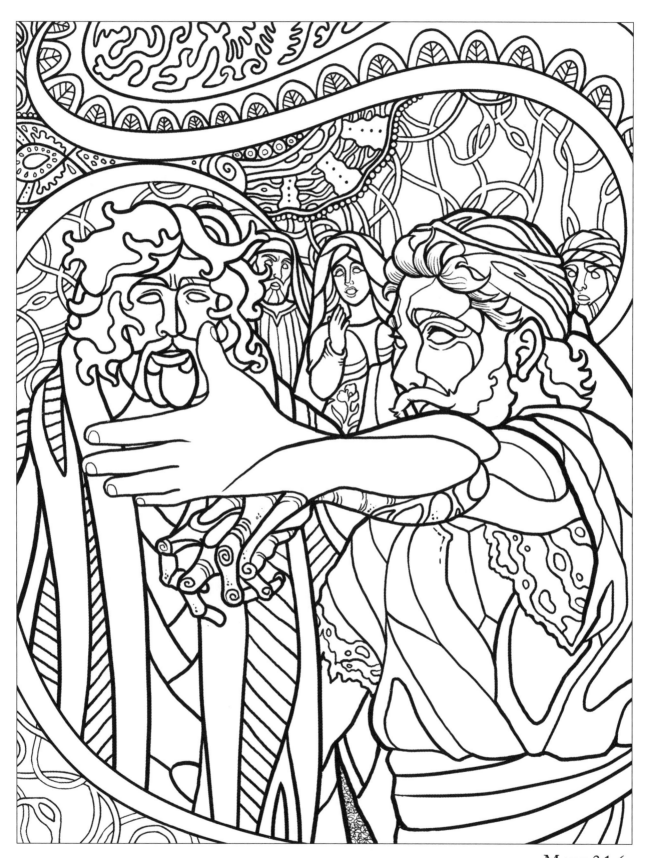

—Mark 3:1-6

Jesus Heals the Woman with the Issue of Blood

Now a certain woman had a flow of blood for twelve years, and had suffered many things from many physicians. She had spent all that she had and was no better, but rather grew worse. When she heard about Jesus, she came behind Him in the crowd and touched His garment. For she said, "If only I may touch His clothes, I shall be made well."

Immediately the fountain of her blood was dried up, and she felt in her body that she was healed of the affliction. And Jesus, immediately knowing in Himself that power had gone out of Him, turned around in the crowd and said, "Who touched My clothes?"

But His disciples said to Him, "You see the multitude thronging You, and You say, 'Who touched Me?'"

And He looked around to see her who had done this thing. But the woman, fearing and trembling, knowing what had happened to her, came and fell down before Him and told Him the whole truth. And He said to her, "Daughter, your faith has made you well. Go in peace, and be healed of your affliction."

—Mark 5:25-34

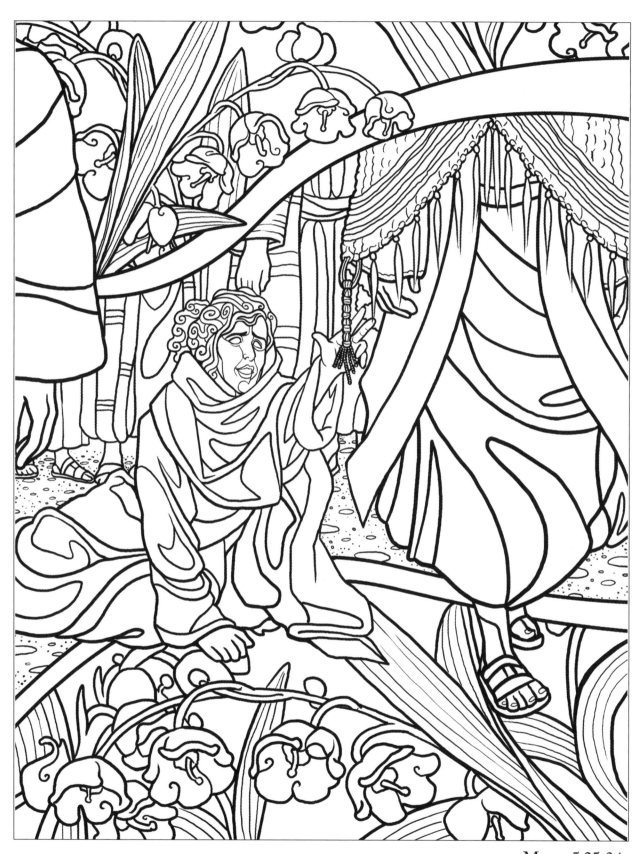

—Mark 5:25-34

JESUS HEALS A DEAF-MUTE

Again, departing from the region of Tyre and Sidon, He came through the midst of the region of Decapolis to the Sea of Galilee. Then they brought to Him one who was deaf and had an impediment in his speech, and they begged Him to put His hand on him. And He took him aside from the multitude, and put His fingers in his ears, and He spat and touched his tongue. Then, looking up to heaven, He sighed, and said to him, "Ephphatha," that is, "Be opened."

Immediately his ears were opened, and the impediment of his tongue was loosed, and he spoke plainly. Then He commanded them that they should tell no one; but the more He commanded them, the more widely they proclaimed it. And they were astonished beyond measure, saying, "He has done all things well. He makes both the deaf to hear and the mute to speak."

—MARK 7:31-37

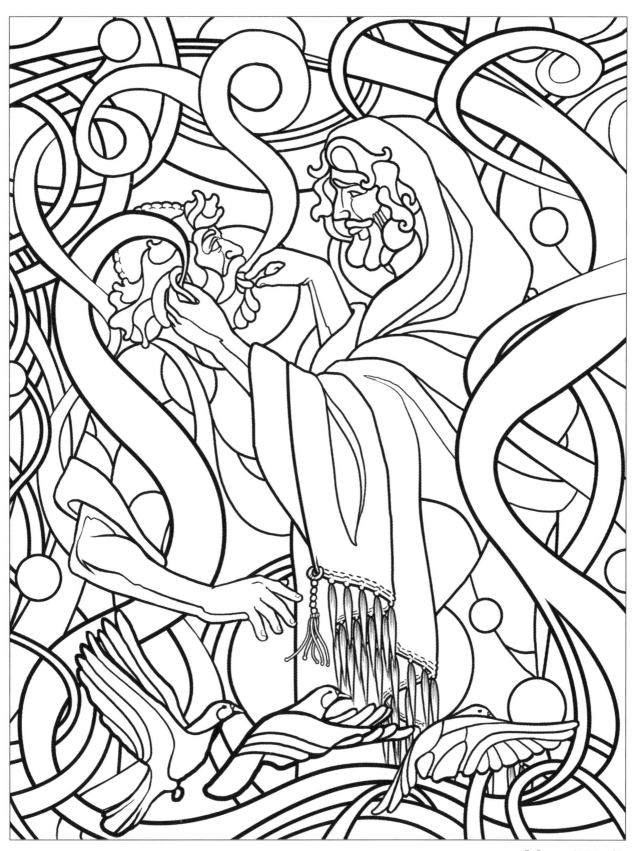

—Mark 7:31-37

A Blind Man Healed at Bethsaida

Then He came to Bethsaida; and they brought a blind man to Him, and begged Him to touch him. So He took the blind man by the hand and led him out of the town. And when He had spit on his eyes and put His hands on him, He asked him if he saw anything.

And he looked up and said, "I see men like trees, walking."

Then He put His hands on his eyes again and made him look up. And he was restored and saw everyone clearly. Then He sent him away to his house, saying, "Neither go into the town, nor tell anyone in the town."

<div align="right">—Mark 8:22-26</div>

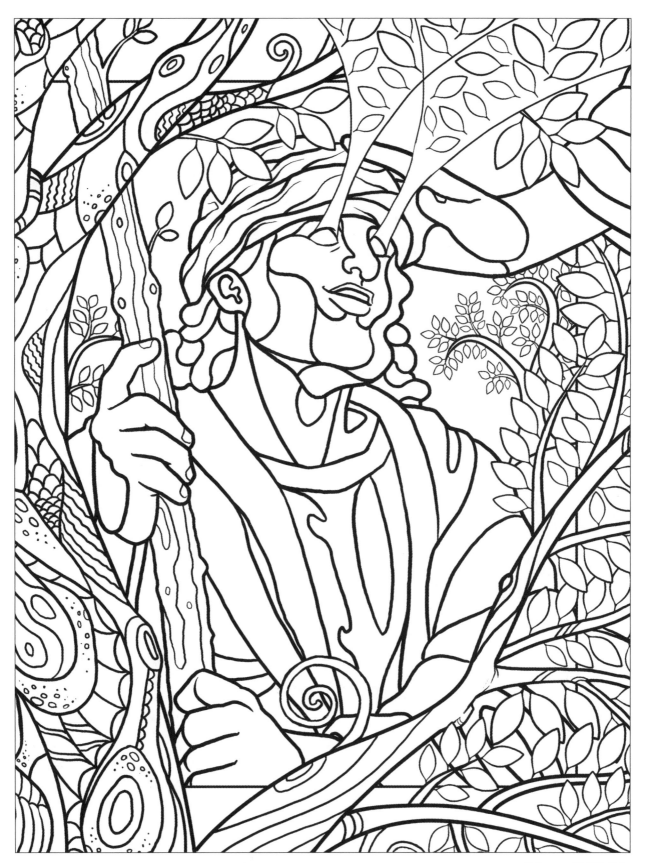

—Mark 8:22-26

JESUS HEALS BLIND BARTIMAEUS

Now they came to Jericho. As He went out of Jericho with His disciples and a great multitude, blind Bartimaeus, the son of Timaeus, sat by the road begging. And when he heard that it was Jesus of Nazareth, he began to cry out and say, "Jesus, Son of David, have mercy on me!"

Then many warned him to be quiet; but he cried out all the more, "Son of David, have mercy on me!"

So Jesus stood still and commanded him to be called.

Then they called the blind man, saying to him, "Be of good cheer. Rise, He is calling you."

And throwing aside his garment, he rose and came to Jesus.

So Jesus answered and said to him, "What do you want Me to do for you?"

The blind man said to Him, "Rabboni, that I may receive my sight."

Then Jesus said to him, "Go your way; your faith has made you well." And immediately he received his sight and followed Jesus on the road.

—MARK 10:46-52

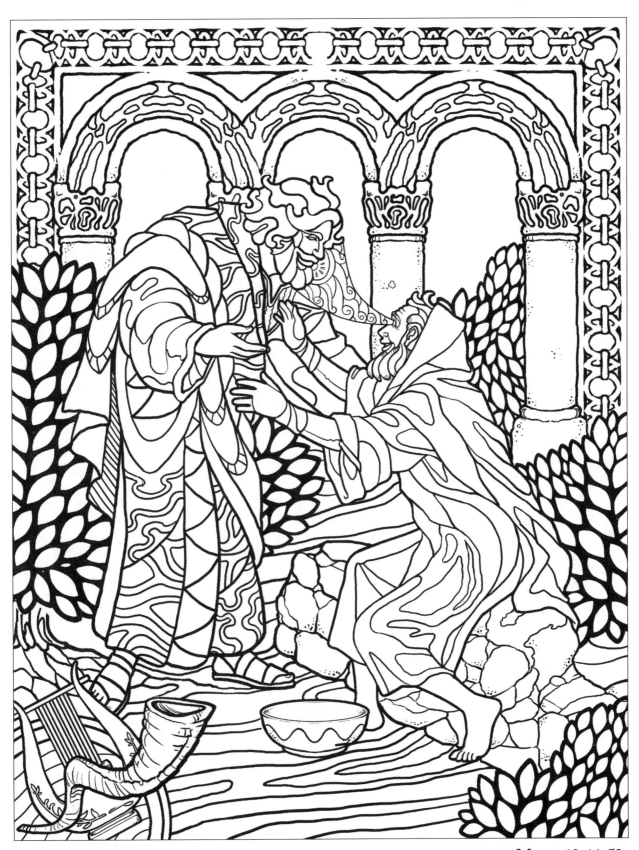

—Mark 10:46-52

Jesus Heals Mary Magdalene and Others

Now it came to pass, afterward, that He went through every city and village, preaching and bringing the glad tidings of the kingdom of God. And the twelve were with Him, and certain women who had been healed of evil spirits and infirmities—Mary Magdalene, out of whom had come seven demons, and Joanna the wife of Chuza, Herod's steward, and Susanna, and many others who provided for Him from their substance

—Luke 8:1-3

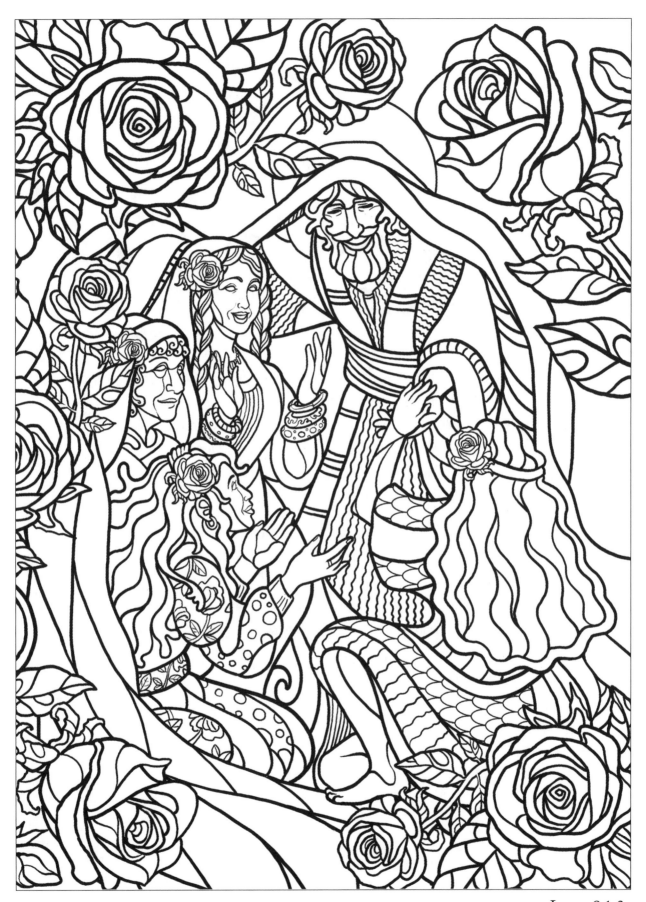

—Luke 8:1-3

Jesus Casts Out an Unclean Spirit

Then He went down to Capernaum, a city of Galilee, and was teaching them on the Sabbaths. And they were astonished at His teaching, for His word was with authority. Now in the synagogue there was a man who had a spirit of an unclean demon. And he cried out with a loud voice, saying, "Let us alone! What have we to do with You, Jesus of Nazareth? Did You come to destroy us? I know who You are—the Holy One of God!"

But Jesus rebuked him, saying, "Be quiet, and come out of him!" And when the demon had thrown him in their midst, it came out of him and did not hurt him. Then they were all amazed and spoke among themselves, saying, "What a word this is! For with authority and power He commands the unclean spirits, and they come out." And the report about Him went out into every place in the surrounding region.

—Luke 4:31-37

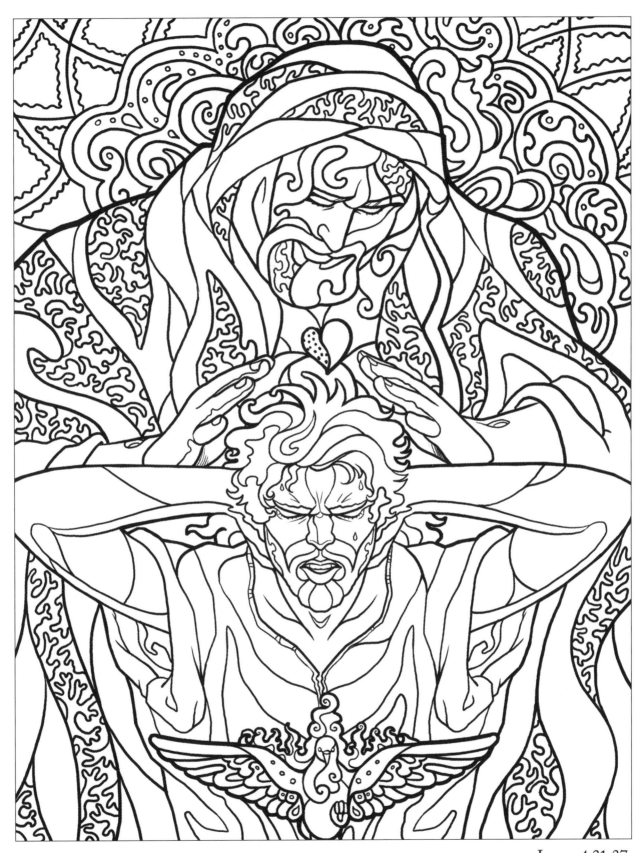

—Luke 4:31-37

JESUS FORGIVES AND HEALS A PARALYTIC

Now it happened on a certain day, as He was teaching, that there were Pharisees and teachers of the law sitting by, who had come out of every town of Galilee, Judea, and Jerusalem. And the power of the Lord was present to heal them. Then behold, men brought on a bed a man who was paralyzed, whom they sought to bring in and lay before Him. And when they could not find how they might bring him in, because of the crowd, they went up on the housetop and let him down with his bed through the tiling into the midst before Jesus.

When He saw their faith, He said to him, "Man, your sins are forgiven you."

And the scribes and the Pharisees began to reason, saying, "Who is this who speaks blasphemies? Who can forgive sins but God alone?"

But when Jesus perceived their thoughts, He answered and said to them, "Why are you reasoning in your hearts? Which is easier, to say, 'Your sins are forgiven you,' or to say, 'Rise up and walk'? But that you may know that the Son of Man has power on earth to forgive sins"—He said to the man who was paralyzed, "I say to you, arise, take up your bed, and go to your house."

Immediately he rose up before them, took up what he had been lying on, and departed to his own house, glorifying God. And they were all amazed, and they glorified God and were filled with fear, saying, "We have seen strange things today!"

—LUKE 5:17-26

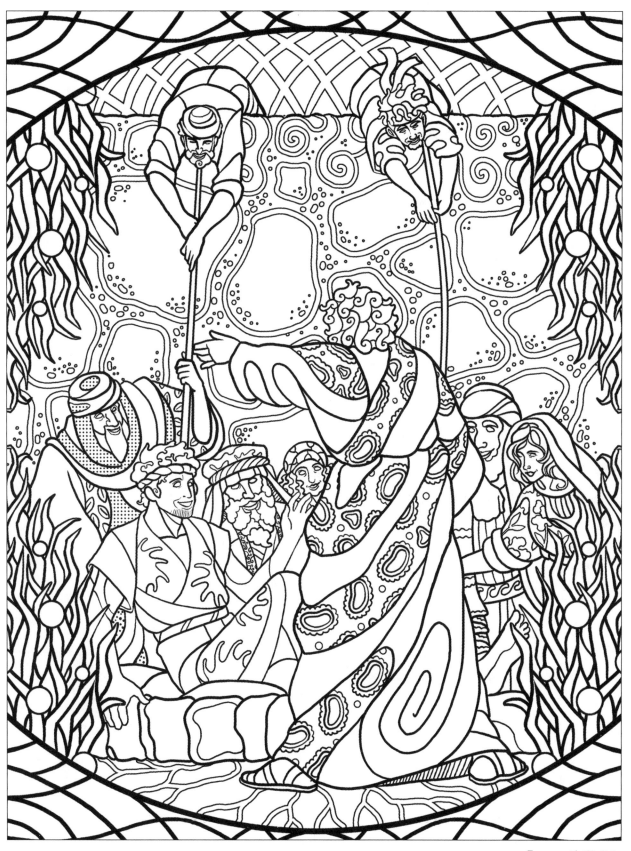

—Luke 5:17-26

JESUS HEALS A CENTURION'S SERVANT

Now when He concluded all His sayings in the hearing of the people, He entered Capernaum. And a certain centurion's servant, who was dear to him, was sick and ready to die. So when he heard about Jesus, he sent elders of the Jews to Him, pleading with Him to come and heal his servant. And when they came to Jesus, they begged Him earnestly, saying that the one for whom He should do this was deserving, "for he loves our nation, and has built us a synagogue."

Then Jesus went with them. And when He was already not far from the house, the centurion sent friends to Him, saying to Him, "Lord, do not trouble Yourself, for I am not worthy that You should enter under my roof. Therefore I did not even think myself worthy to come to You. But say the word, and my servant will be healed. For I also am a man placed under authority, having soldiers under me. And I say to one, 'Go,' and he goes; and to another, 'Come,' and he comes; and to my servant, 'Do this,' and he does it."

When Jesus heard these things, He marveled at him, and turned around and said to the crowd that followed Him, "I say to you, I have not found such great faith, not even in Israel!" And those who were sent, returning to the house, found the servant well who had been sick.

—LUKE 7:1-10

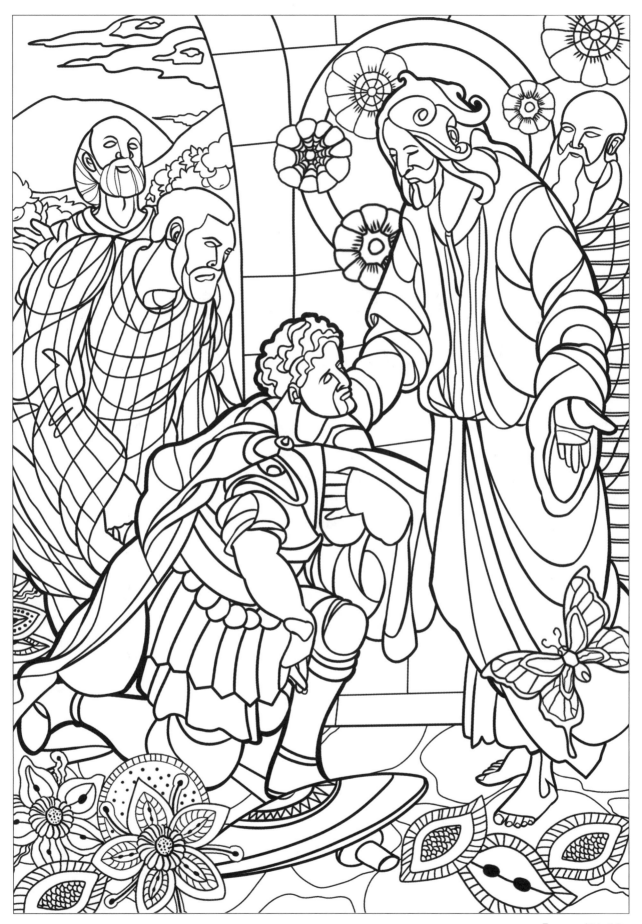

—Luke 7:1-10

JESUS RAISES THE SON OF THE WIDOW OF NAIN

Now it happened, the day after, that He went into a city called Nain; and many of His disciples went with Him, and a large crowd. And when He came near the gate of the city, behold, a dead man was being carried out, the only son of his mother; and she was a widow. And a large crowd from the city was with her. When the Lord saw her, He had compassion on her and said to her, "Do not weep." Then He came and touched the open coffin, and those who carried him stood still. And He said, "Young man, I say to you, arise." So he who was dead sat up and began to speak. And He presented him to his mother.

—LUKE 7:11-15

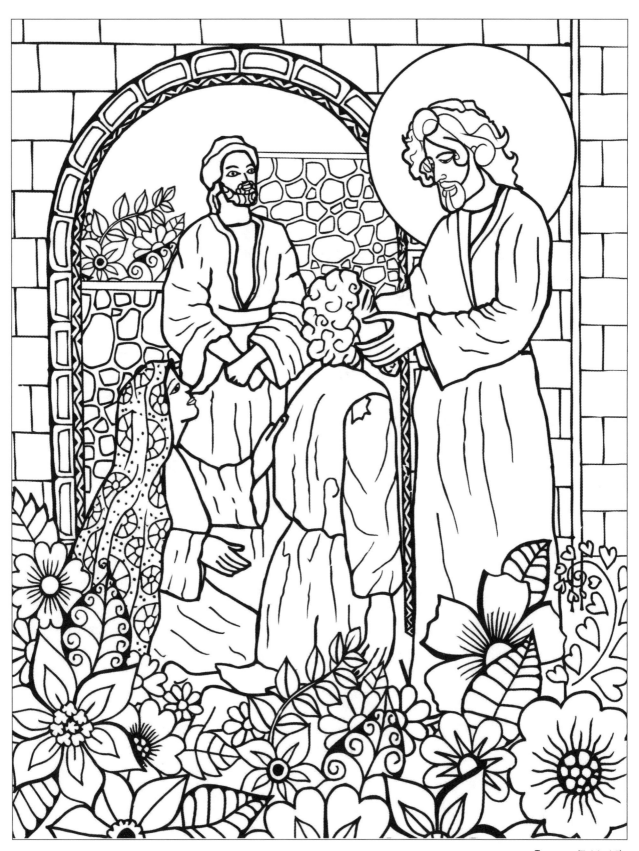

—Luke 7:11-15

JESUS RAISES UP THE DAUGHTER OF JAIRUS

While He was still speaking, someone came from the ruler of the synagogue's house, saying to him, "Your daughter is dead. Do not trouble the Teacher."

But when Jesus heard it, He answered him, saying, "Do not be afraid; only believe, and she will be made well." When He came into the house, He permitted no one to go in except Peter, James, and John, and the father and mother of the girl. Now all wept and mourned for her; but He said, "Do not weep; she is not dead, but sleeping." And they ridiculed Him, knowing that she was dead.

But He put them all outside, took her by the hand and called, saying, "Little girl, arise."

—LUKE 8:49-54

—Luke 8:49-54

Jesus Casts a Demon Out of a Mute

And He was casting out a demon, and it was mute. So it was, when the demon had gone out, that the mute spoke; and the multitudes marveled. But some of them said, "He casts out demons by Beelzebub, the ruler of the demons."

Others, testing Him, sought from Him a sign from heaven.

But He, knowing their thoughts, said to them: "Every kingdom divided against itself is brought to desolation, and a house divided against a house falls. If Satan also is divided against himself, how will his kingdom stand? Because you say I cast out demons by Beelzebub. And if I cast out demons by Beelzebub, by whom do your sons cast them out? Therefore they will be your judges. But if I cast out demons with the finger of God, surely the kingdom of God has come upon you. When a strong man, fully armed, guards his own palace, his goods are in peace. But when a stronger than he comes upon him and overcomes him, he takes from him all his armor in which he trusted, and divides his spoils. He who is not with Me is against Me, and he who does not gather with Me scatters.

—Luke 11:14-23

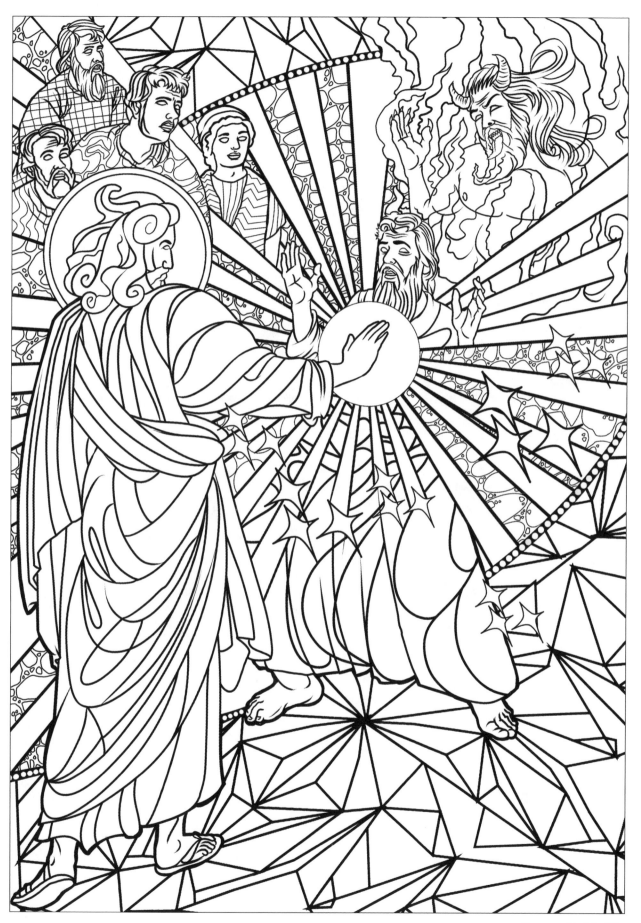

—Luke 11:14-23

JESUS HEALS A WOMAN WITH A SPIRIT OF INFIRMITY

Now He was teaching in one of the synagogues on the Sabbath. And behold, there was a woman who had a spirit of infirmity eighteen years, and was bent over and could in no way raise herself up. But when Jesus saw her, He called her to Him and said to her, "Woman, you are loosed from your infirmity." And He laid His hands on her, and immediately she was made straight, and glorified God.

—LUKE 13:10-13

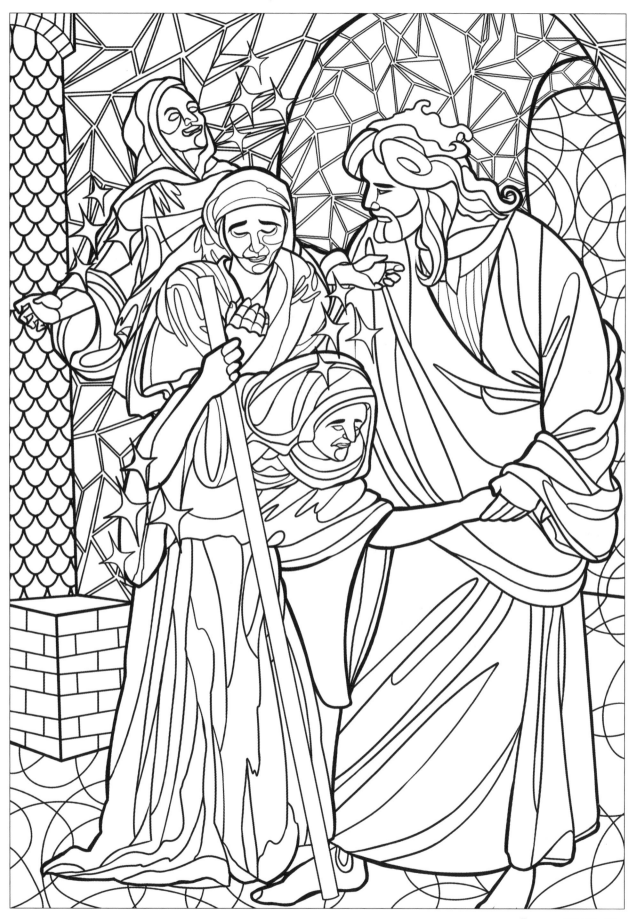

—Luke 13:10-13

JESUS HEALS A MAN OF SEVERE SWELLING

Now it happened, as He went into the house of one of the rulers of the Pharisees to eat bread on the Sabbath, that they watched Him closely. And behold, there was a certain man before Him who had dropsy [severe swelling]. And Jesus, answering, spoke to the lawyers and Pharisees, saying, "Is it lawful to heal on the Sabbath?"

But they kept silent. And He took him and healed him, and let him go.

—LUKE 14:1-4

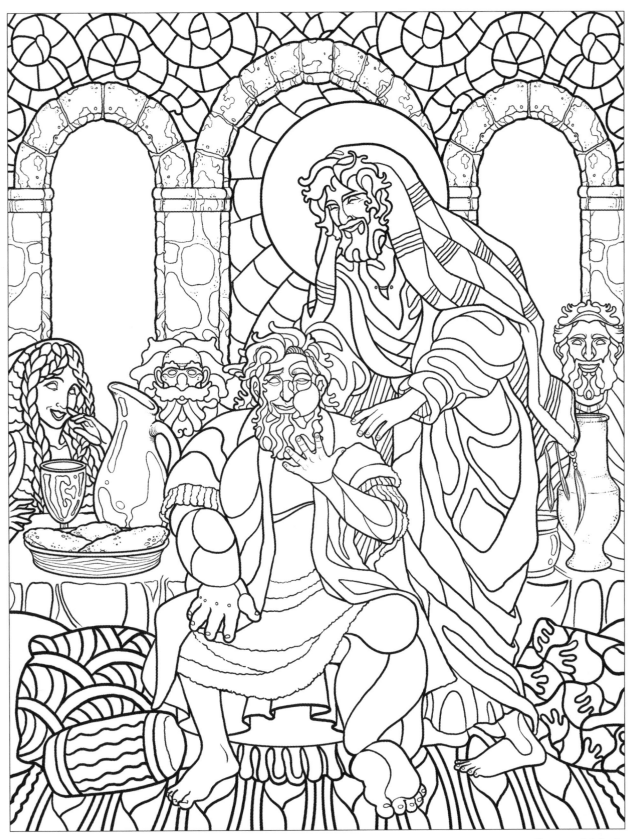

—Luke 14:1-4

TEN LEPERS CLEANSED

Now it happened as He went to Jerusalem that He passed through the midst of Samaria and Galilee. Then as He entered a certain village, there met Him ten men who were lepers, who stood afar off. And they lifted up their voices and said, "Jesus, Master, have mercy on us!"

So when He saw them, He said to them, "Go, show yourselves to the priests." And so it was that as they went, they were cleansed.

—LUKE 17:11-14

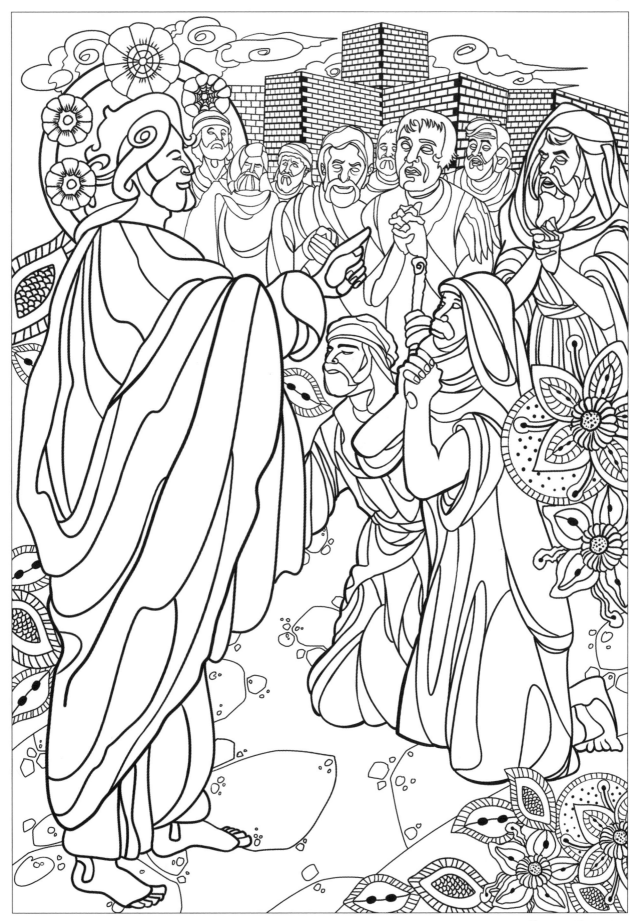

—Luke 17:11-14

Jesus Heals a Thankful Samaritan of Leprosy

And one of them, when he saw that he was healed, returned, and with a loud voice glorified God, and fell down on his face at His feet, giving Him thanks. And he was a Samaritan.

So Jesus answered and said, "Were there not ten cleansed? But where are the nine? Were there not any found who returned to give glory to God except this foreigner?" And He said to him, "Arise, go your way. Your faith has made you well."

—Luke 17:15-19

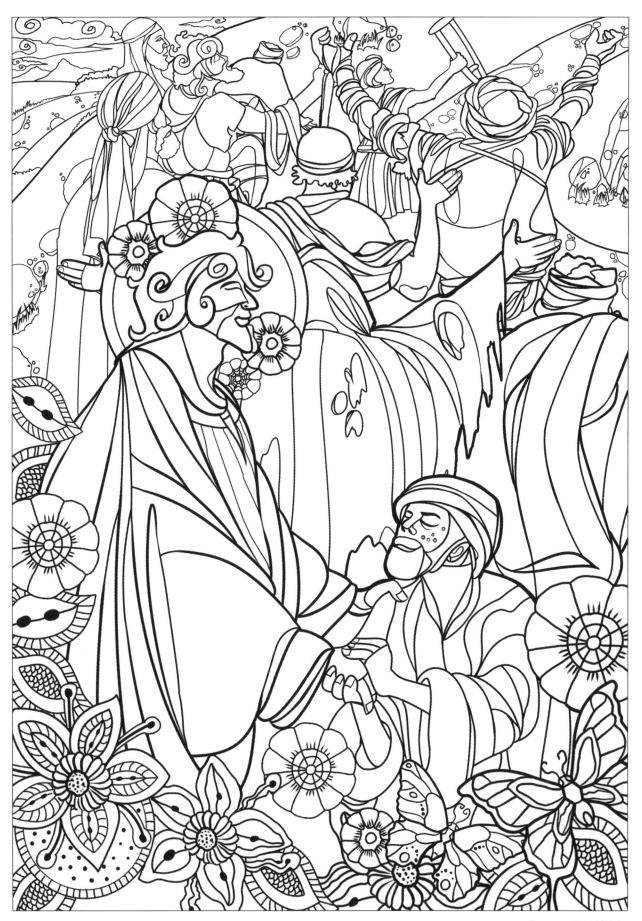

—Luke 17:15-19

A Blind Man Receives His Sight

Then it happened, as He was coming near Jericho, that a certain blind man sat by the road begging. And hearing a multitude passing by, he asked what it meant. So they told him that Jesus of Nazareth was passing by. And he cried out, saying, "Jesus, Son of David, have mercy on me!"

Then those who went before warned him that he should be quiet; but he cried out all the more, "Son of David, have mercy on me!"

So Jesus stood still and commanded him to be brought to Him. And when he had come near, He asked him, saying, "What do you want Me to do for you?"

He said, "Lord, that I may receive my sight."

Then Jesus said to him, "Receive your sight; your faith has made you well."

—Luke 18:35-42

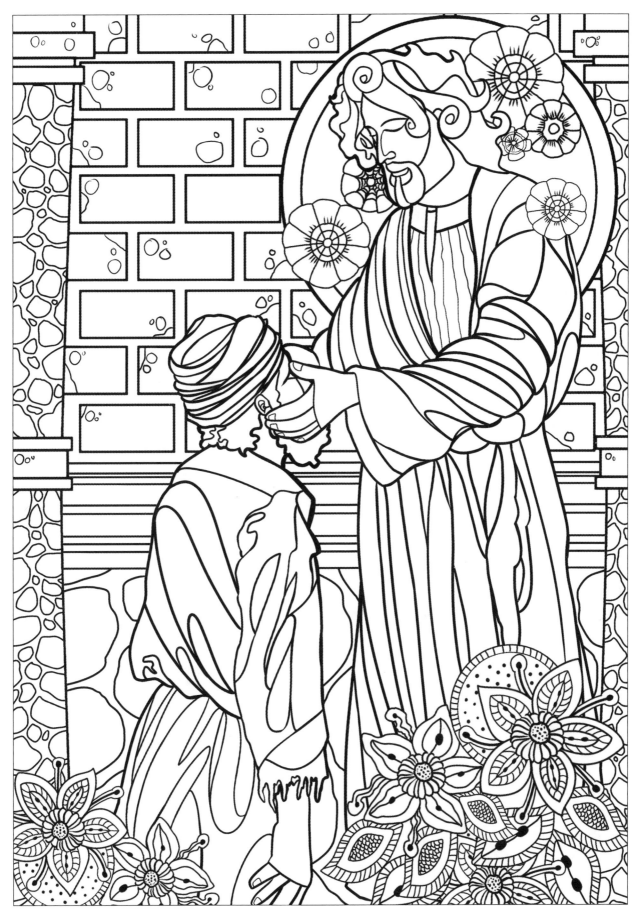

—Luke 18:35-42

A Nobleman's Son Healed

So Jesus came again to Cana of Galilee where He had made the water wine. And there was a certain nobleman whose son was sick at Capernaum. When he heard that Jesus had come out of Judea into Galilee, he went to Him and implored Him to come down and heal his son, for he was at the point of death. Then Jesus said to him, "Unless you people see signs and wonders, you will by no means believe."

The nobleman said to Him, "Sir, come down before my child dies!"

Jesus said to him, "Go your way; your son lives." So the man believed the word that Jesus spoke to him, and he went his way. And as he was now going down, his servants met him and told him, saying, "Your son lives!"

Then he inquired of them the hour when he got better. And they said to him, "Yesterday at the seventh hour the fever left him." So the father knew that it was at the same hour in which Jesus said to him, "Your son lives." And he himself believed, and his whole household.

This again is the second sign Jesus did when He had come out of Judea into Galilee.

—John 4:46-54

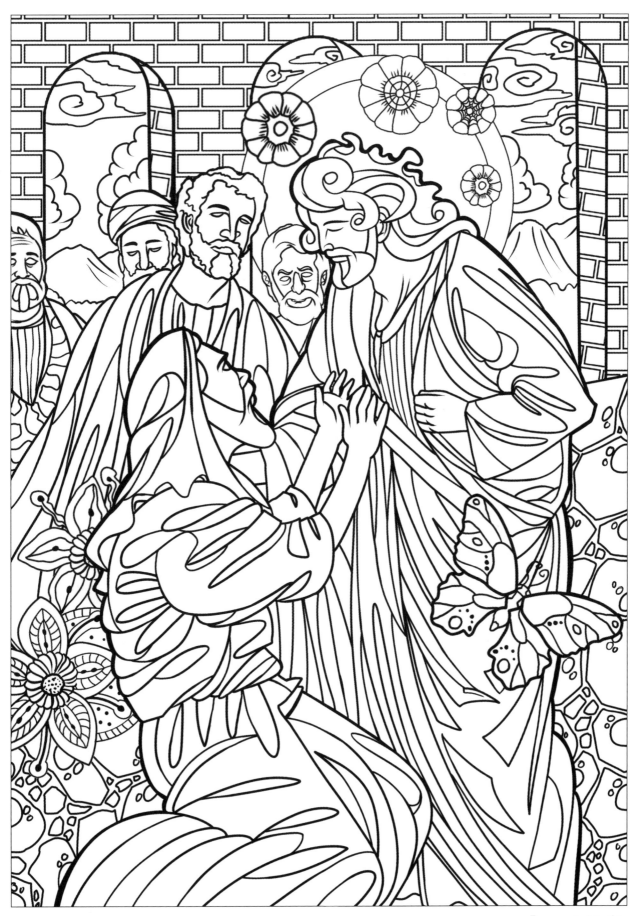

—John 4:46-54

A Man Healed at the Pool of Bethesda

After this there was a feast of the Jews, and Jesus went up to Jerusalem. Now there is in Jerusalem by the Sheep Gate a pool, which is called in Hebrew, Bethesda, having five porches. In these lay a great multitude of sick people, blind, lame, paralyzed, waiting for the moving of the water. For an angel went down at a certain time into the pool and stirred up the water; then whoever stepped in first, after the stirring of the water, was made well of whatever disease he had. Now a certain man was there who had an infirmity thirty-eight years. When Jesus saw him lying there, and knew that he already had been in that condition a long time, He said to him, "Do you want to be made well?"

The sick man answered Him, "Sir, I have no man to put me into the pool when the water is stirred up; but while I am coming, another steps down before me."

Jesus said to him, "Rise, take up your bed and walk." And immediately the man was made well, took up his bed, and walked.

And that day was the Sabbath. The Jews therefore said to him who was cured, "It is the Sabbath; it is not lawful for you to carry your bed."

He answered them, "He who made me well said to me, 'Take up your bed and walk.'"

Then they asked him, "Who is the Man who said to you, 'Take up your bed and walk'?" But the one who was healed did not know who it was, for Jesus had withdrawn, a multitude being in that place. Afterward Jesus found him in the temple, and said to him, "See, you have been made well. Sin no more, lest a worse thing come upon you."

The man departed and told the Jews that it was Jesus who had made him well.

—John 5:1-15

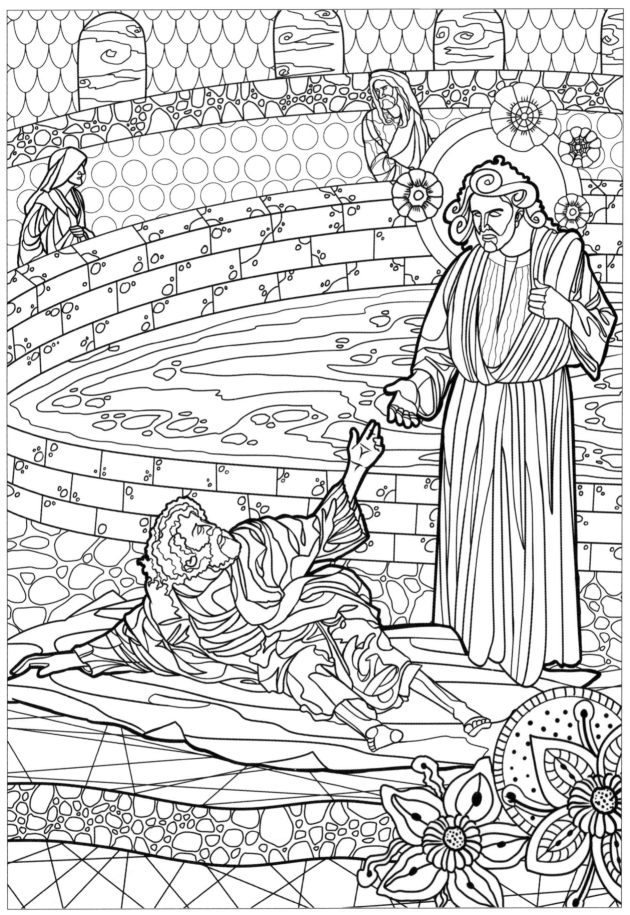

—John 5:1-15

LAZARUS RAISED FROM THE DEAD

Then Jesus, again groaning in Himself, came to the tomb. It was a cave, and a stone lay against it. Jesus said, "Take away the stone."

Martha, the sister of him who was dead, said to Him, "Lord, by this time there is a stench, for he has been dead four days."

Jesus said to her, "Did I not say to you that if you would believe you would see the glory of God?" Then they took away the stone from the place where the dead man was lying. And Jesus lifted up His eyes and said, "Father, I thank You that You have heard Me. And I know that You always hear Me, but because of the people who are standing by I said this, that they may believe that You sent Me." Now when He had said these things, He cried with a loud voice, "Lazarus, come forth!" And he who had died came out bound hand and foot with graveclothes, and his face was wrapped with a cloth. Jesus said to them, "Loose him, and let him go."

—JOHN 11:38-44

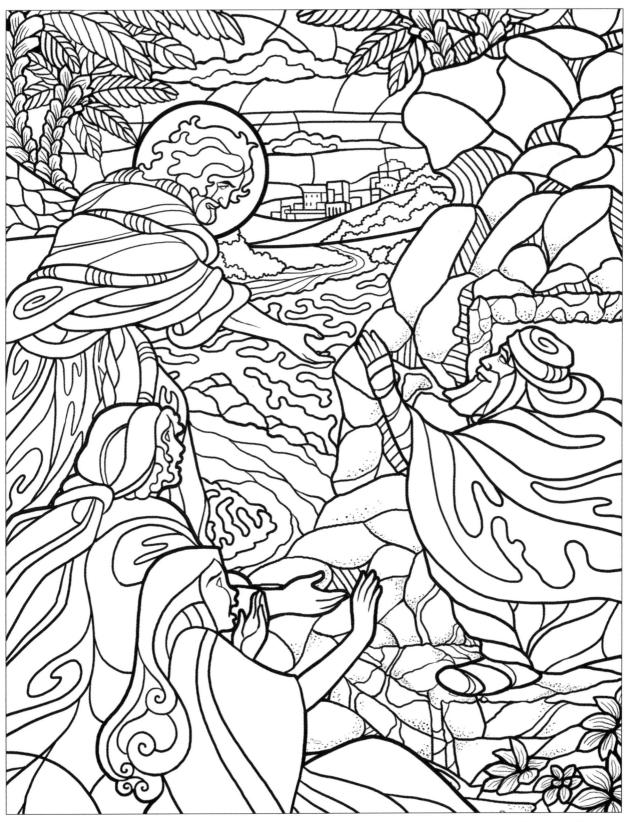

—John 11:38-44

Jesus Heals the Servant of the High Priest in Gethsemane

And while He was still speaking, behold, a multitude; and he who was called Judas, one of the twelve, went before them and drew near to Jesus to kiss Him. But Jesus said to him, "Judas, are you betraying the Son of Man with a kiss?"

When those around Him saw what was going to happen, they said to Him, "Lord, shall we strike with the sword?" And one of them struck the servant of the high priest and cut off his right ear.

But Jesus answered and said, "Permit even this." And He touched his ear and healed him.

Then Jesus said to the chief priests, captains of the temple, and the elders who had come to Him, "Have you come out, as against a robber, with swords and clubs? When I was with you daily in the temple, you did not try to seize Me. But this is your hour, and the power of darkness."

—Luke 22:47-53

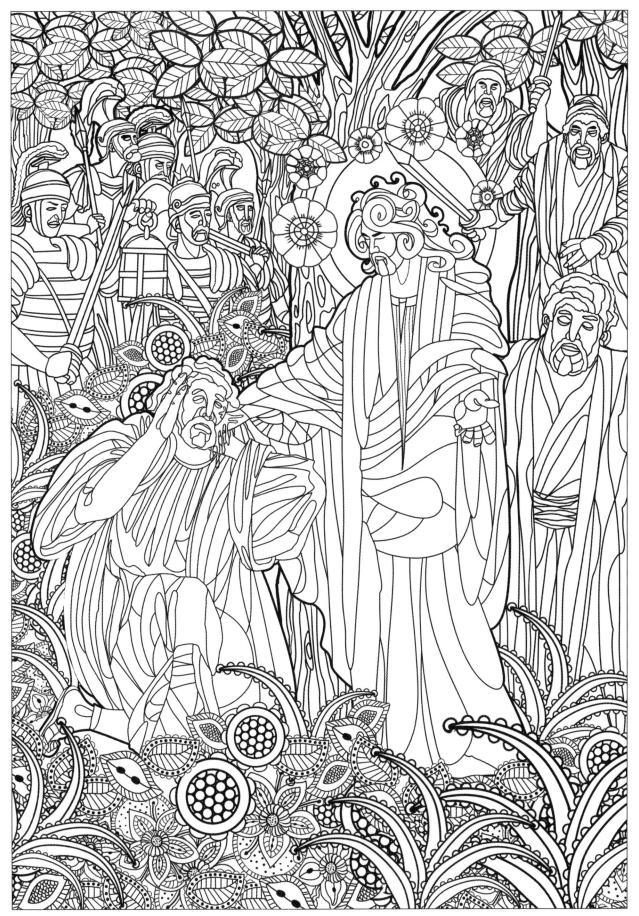

—Luke 22:47-53